INDIAN NIGHTINGALES
ENGLISH RENDERING

INDIAN NIGHTINGALES ENGLISH RENDERING

Transcreations for poems of Indian poets

RAAMAA

PARTRIDGE

To order additional copies of this book, contact
Partridge India
000 800 10062 62
orders.india@partridgepublishing.com

www.partridgepublishing.com/india

Contents

Preface

When I read some poems in my mother tongue Telugu or national language Hindi, I derive great joy. Due to that I read them for many a time. Off course in every reading I find new flavor in them. Then I felt that our next generation children and the remaining world are deprived of these poetic flavors. Similarly when I read English rhymes, I feel that "can't we have native rhymes in the present context?" Because some of the rhymes have no relevance to present generation and also if they were presented with some simple changes, our new generation kids feel more interesting.

I tried to portrait some of the interesting poems in my own style by transcreation. My theme of work is well presented in the 1st poem itself. I convey my sincerest thanks to all poets who contributed their poems for this book. I also thank M/S Partridge India Publishing House for giving this opportunity for me.

-Machiraju Rama Prasad

Foreword

P.Chidambaram Rao
Freelance artist
Vijayawada, AP,
INDIA
Cell: 9959646179

Mail: chidambarampavuluri@gmail.com

*I*can certainly say that the poetry book "INDIAN NIGHTINGALES ENGLISH RENDERING" is unique and heart touching. The contents are also very diversified. You find rhymes, poems, satires what not in these translations. I feel proud to be part of this book as an artist. Readers can enjoy in two ways for reading and seing the sketches which make them to think and recall

Sd/-
P.Chidambaram Rao

Foreword

Dr.M.Ram Sunder Rao
PRINCIPAL(Retd)
Govt. Ayurvedic Medical College
Vijayawada, AP. India
Cell: 9440518837
Mail:madhava.madiraju@yahoo.com

*M*y nepvew as well as my dear poet Mr Prasad opens his book with a saying "Feel proud to be mad". A man who reaches the peak level of devotion and concentration on an object or subject becomes unaware of the external world. He doesnot know whether he dressed well or naked awkwardly, whether he has his routine meal or fasting for long. He would be busily immersed in his own escatasy. But here we have to take a positive note of the madness who make this world.

The opening versae " I am a poet" shows his self confidence and commitment to his duty to enlighten and entertain the society with anything and everything. At his hand right from the matchstick to mount everest.

Yes! my dear poet! we are here to welcome your poetry and with that it would quench the thirst of ideal and thought provoking literature.

In the 2 nd verse, the poet has so simply and tremendously described the quarrel among tomoto, brinjal, coriander, onion,and drumstick. But alas! They get dissolved and unite with their boss "sambar". This is really a leson to the politicians who pose their individuality alone to be superior.

Thirdly fan. Really we, the readers too are the fans of fan. But we ignore and abhore its inventor.

Next 4th poem is so sweet and simple. In the poem 6 on TV, the poet touched only the benefits of it such as gaming,earning, learning etc. However, he did not touch the ill effects of it.

Kite is small poem but throws a thought that life without restrains is like kite with broken thread.

In the poem "game" ,we the spectators are also part of the game who trust the players elated the heart and orders. The players are divided into rival groups but not individual players.

Finally I admire Mr Machiraju Rama Prasad and congratulate him for his efforts in bringing out this anthology of poems. I wish him all the best.

Sd/-
Dr.M.Ram Sunder Rao

Profile of my poets

*F*irstly **Dr. Kavoori Papaiah Sastri** is Professor (Retd) in Telugu in Govt. Degree college. He is versatile poet and writes in forms of Telugu poems. Rangula Nadi, Pravaaha Geetham, Sri sri shatakam, Picchuka.. Picchuka.. etc are his works in Telugu. He gave lectures on Maha Bhagavatham at All India Radio,Kothagudem. (can be seen as Bhagavatha makarandam in you tube) and has written books on many subjects.

Coming to **Mrs.Talluri Subba Lakshmi** is Lecturer (Retd) in English and lives in Bhilai of Chhattisgarh state and writes poetry in almost all forms. She is story and drama writer. She is also stage artist.

Mr.KBDL Stone is also a Lecturer and stays at Markapur of Ongole district in AP. His poetry is known for simplicity and many of poetic anthologies came as books such as Khanditha swapnaalu, Shoolammithy, Aaku paccha shokam etc. His poems were published in many of the Telugu news papers and magazines.

Dr Yendluri Sudhakar is Professor in Telugu at Sri Potti Sriramulu Telugu University, Hyderabad. He is known for his simplicity in his poetry but his spark is un matching. His works include Nalla Draksha Pandiri, ATA jani kanche(A travelogue poetry) etc.

Prof. Raama Chandra Mouli is Professor in Mechanical Engineering and lives in Warangal, Tealangana. He is very very versatile poet, novelist, story writer, critic and won many awards. Many of his works were translated in to many languages. He represented the country to Greek as poet. He also attended SAARC poets summit.He also contributed stories, dialogue for Telugu film industry. I am very proud to have his poem here.

Mr. Potlapally Sreenivasa Rao works as Registrar and stays at Warangal. He is popular for his free verses. His poems are frequently seen in Local Telugu news papers.

Mrs. Devulapally Vani Devi is Professor in English at National Institute of Technology, Warangal and writes poems spontaneously on contemporary social issues.

Mr. P.Subbarayudu is an Electrical Engineer hailing from Hyderabad is poet; story writer and his works are mainly on nature.

Dr Talluri Ravi is Psychiatrist and stays in Australia and his personal feelings when written look like poems. Such a poet, he is.

Mr Raparthy Shankar is Principal, Govt. Polytechnic, Warangal. In spite of his very busy life, the spark in him makes a poet frequently. Antha ranga raagaalu is anthology of poems.

Mr. Gurijaala Raama Sheshaiah is retired Telugu Lecturer and poet, critic etc. He is known for his book Vishwambhara Anusheelana in which he analyzed the popular poet Dr C. Narayana Reddy's Jnaanapeet award winning poetry Vishwambhara.

1. I am a poet

I *am a poet*
I am proud to say it.
Whatever is the object, I find subject
Whatever is the subject I put it in the best
Whatever is situation, I may find a poetic illustration
Whether it is journey, tourney, chimney
It is immaterial, which may materialize into a poem
It is after all my mind, which has to mold any into poem

Rhyming is my strength
Dreaming is my wealth
Narration is down to earth
Now the readers may be a dearth

Tomorrow you find the readers on the entire earth
Brevity is my art touching the heart
That is the secret of my poet
I work to earn
I learn to write
I earn joy in writing

If you churn joy in my works,
my poetry is blessed by the goddess
I create I translate I compose finally
I present for my joy first
Readers applaud is welcome
Reader's criticism is most welcome
Finally readers are welcome to read my poems

2. Chef's Verdict

Tomato boasted "I am so cute fruit"
And fit to be used in many broths
Then brinjal countered
"I am also too great and known for my might"

> *In between drum stick entered the fray and*
> *Beats the drum to raise the heat of debate*
> *Seeing all this, onion spread its spicy flavor*
> *and asked for the vote in its favor*

Do not ignore us, we are also in fray said
coriander and curry leaves

> *Then the chef passed its verdict*
> *"all of you are good for me*
> *But I don't allow your fighting and make*
> **sambar with all of you*
> *To enjoy all of your flavors"*

My verdict is without any fear
but in favor of my connoisseur

* **Sambar** *is south Indian Dish made up of all vegitables.*

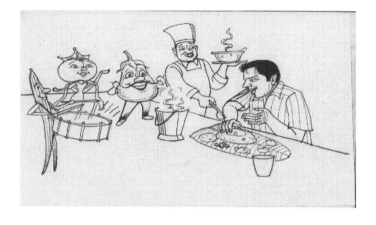

3. Fan------ fan I am your fan

*F*an------ *fan I am your fan*
*When you are **on** sweats are **off***
*When you are **off**, sweats are **on***
Take a rest during winter
to work without rest in the summer
Fan fan I am your fan

4. Coming on the towers

Coming over the towers
Bringing us the power
Faraday's generation
Edison's invention
O power You are Today's compulsion

5. System system

System system
Today's custom custom
I need you for learning
I need you for earning
I need you for gaming
I need you for shopping
I need you for net working
System system
Today's custom custom

6. Television --- television

Television --- television
you gave me a long vision
I watch the games I view the scenes
Far off from my vision
Cartoon network, pogo come to me
That's why I come to you o my television.. You gave me a
long vision

7. "Motor -Motor"

*M*otor—*motor water lifter*
from our well to fill over head tank
to give us over head shower
to peel off heat from our hearts

8. Kite ---kite fly at a great height

*K*ite ---kite fly at a great height
I pull the thread to send you ahead
When you struck, thread is prick
You can't come back
I can't bear your tear

9. Radio ----o my audio wonder

*R*adio ----o my audio wonder
Marconi's invention
Communication revolution
No wires, only air waves bring us the AIR
*Here note that AIR stands for **All India radio** which is official radio of Govt. of India.*
You know that Marconi is the scientist who invented Radio which brought a major change in communication. This needs only radio waves and does not need any wires.

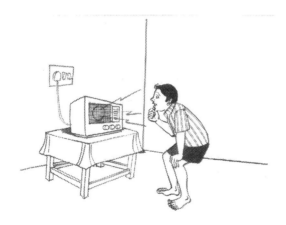

10. Rain rain go away

*H*ere is the popular rhyme on rain. Read it and also see modified version in Indian and children context.

Rain rain go away,
Come again another day.
Little Johnny wants to play;
Rain, rain, go to Spain,
Never show your face again!

Ours is dry and hot climate. The draughts are common in our country. Mostly we can't say go away to rain. Our kids enjoy a lot with rain. Thus the rain rhyme for kids of our country is

Rain rain come again everyday
Let's play as and when you come
Our crops looking for you
Our taps waiting for you
Our wells needs a fill
We become well with you
You never suffer us
We ever pray for you

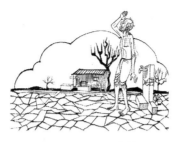

Another idea of rain rhyme is as follows

Rain rain come again
When I am at home
Don't come when I am not at home
I would like to play with you
If you come when I am not in home I can't play
and I can't become wet.
Hence set to come when I am at home

11. Cockroach! cockroach! I approach you

Boy: Cockroach cockroach I approach you
Cockroach: Don't come don't come I am moving away

 U can't meet me…… U can't beat me

Boy: Cockroach cockroach I come to you

 And hit you with *Hit to kill you.

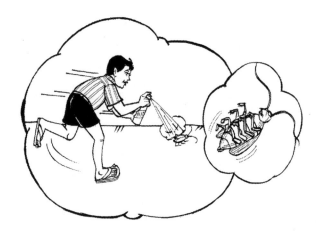

* **Hit** is an insectide to kill cockroaches.

12. Tring tring phone Tring tring phone

*T*ring tring phone Tring tring phone
 Coming from the known
How are you known how do you do my known
Tring tring phone Tring tring phone
Coming from the unknown

Asking **Aap hi koun* makes them known
If not cut the phone
Tring tring phone Tring tring phone

* **Aap hi koun** is a Hindi phrase meaning that who are you?

13. Banganapalli mangoes

- *Banganapalli mangoes well well well*
- *Konaseema coconuts chill chill chill*
- *Vadlamudi oranges thrill thrill thrill*
- *Pullareddy sweets will will will*
- *Palasa cashew bill bill bill*

- Banganapally, Konaseema, Vadlamudi, Palasa are places which are famous for them. Pullareddy is famous sweet shop of Hyderabad

14. Wonder nut

Wonder nut what a nut?
What is it? Ground nut
Breaks with sound
Keeps the health sound

15. Healthy leaves

L *ovely leaves lively leaves*
 Healthy leaves
Gives the health
Saves the wealth
*Rich in *nutrients*
What are those?
They are the leafy vegetables

* Nutrients mean vitamins and minerals useful for our body.

16. O! moon O! moon

O moon o moon you look so smart in the sky
Why do you stay at such a great height?
Why don't you come down?
Are playing with the stars?
You come down on to earth!
If youi come I eat, other wise I weep
We play together! We both roam with joy

17. Sweety sweety talks

*C*ome on come on o my cute kids
By eating tender leaves of mango, how beatyfully the
nightingale sings!
By eating sore leaves, how cutely the parrot speaks!
We being the humans why to have anger which is a great
disorder
Let us cheerfully speak and bring pleasance in the ambience

18. We go to school

*B*uds! Come on come on! we go to scholl to read and write
We become literates and lit the lights of developments
to overtake others
No question of illiteracy
By reading and writing we go ahead
We are the future of the country
We join together to strengthen the country

19. Rural girl's plea

Mum I go school
 Mum I go to scholl
Taking the slate and chalk
I go to school
I learn alphabets
To bet and beat this world
I learn tables and
Do the wonders of maths
I go to moon
And do many many
*I become *Indiramma and*
*Get the name to **Indiamma*

* *Indiramma was former Prime Minister of India*
** *Indiamma is coined word symbolizing Mother India*

20. Goddess in hands

G odess of prosperity in my hand
 Godess of learning in my palm
These hands make me strong
That is why I look in to my hand in the morning.

21. Mother earth

*S*eas are your costumes
In which you look so cute
Hills are your breasts
Giving us the lively water
You are the great mum
Even gods do not have.

22. Anger

*G*reat men keep their anger for a moment
 Commeners keep it for seconds
Shallow men keep it for days
Sinners keep it for ever

23. Lord's assurance

*T*o safeguard the good
 To nullify bad
I take birth from time to time

24. Famine

Really drought is fatal
How much greenery it took away?
To what extent, it has curbed the life?
The villages weeping with thirsty throats
The deserted paddy fields unable to tear
The cloudless sky is like lifeless habitat
Scenes of
Streams of Rain water in the streets:
Kids building dams across such streams!
Not seen!
Scenes of
Wonderful paper boats!
Not seen!
Scenes of
Musical tunes of sound when
array of paddy plants wet in drizzle!
Sounds of stream flowing in between the paddy fields!
Colorful wonder of rain bow!
Not seen!

What happened to all those?
All those are missing as they were caught by the famine

What is seen now in this famine?

Vultures flying in the sky as starving creatures die
The wrinkled belly weeping moms with their babes in arms
The dried, cracked rural lakes and paddy fields in the
nearby eye sight is the scene portrayed by merciless
famine with the former's tears

25. Win! Win! *Rahaman

*B*y birth he is great.
From nano to mega, mega to mighty,
He became maestro
His heart is sea of music.
All his thoughts are butterflies in the music of garden
He tunes melody in all his deeds.
He tunes melodies with the innocent smiles of infants
He beats for resonance between the heart beats of a couple.
He articulates the cheerful feel of almighty
when devotees lit &pray from the temple.
He manifests summer gale, winter cool,
rain fall, snow fall in his recital
He rocks national anthem on the rolling
sand grains of desert.
The tall trees of brooks can sing national song in his swings
His beats can be slow pace of elephant and swift of deer
He stalls time with his maestro and binds the ends of this world
He brings happy the tears in the eye of mother India
He is the pride of flying tri color flag.
O! Rahaman!Win! Win!
To uphold the pride of our Mother India

* **AR RAHAMAN IS MUSIC COMPOSER, WON THE OSCAR AWARD**

26. My transcreations

*W*hen I read the poem, I may be delighted.
　　This delight ends only when it delights others.
As I can't orally delight all others,
I try to delight others with my transcreation.
It's my passion and my creation.

27. *Kamatipura

*T*he traces of burnt dhoop sticks.
 The movement of terrifying shadows.
The flowers with dropped petals.
The odors of burning desires, burnt hearts
The petrified melancholies from muted souls.
The blubber of caged parrots with leaned voice
Life boats in danger of storms and whirls.
This is scene of obscenity created by our mankind.

* **Kamathipura** is **Mumbai** (India)'s oldest and Asia's largest
 red-light area.

28. Game

*A*ll those are players.
 All of us are spectators.
We enjoy as if they are playing for us
We feel proud as if they are playing for nation.
They look like people with ethics
Their commitment, patriotism looks like unquestionable.
Spectators have greatest trust on the players
With elated heart, endless regards spectators love them.
Players being divided into rival teams, fight with devotion!
Everybody has their own strategy!
On the political arenas,
International platforms showing their acumen,
With greatest passion to win others, they fight out.
With a great anxiety, we see such events forgetting to breathe
We all are common spectators.
Many secrets of the game we do not know
We are simply involved in viewing

29. O sky! I like you

*O*n every night with all its eyes and cheers it wishes me.
Its eyes are so cute and bright expressing musical
melodies of light.
Day and night, it illuminates the globe! Then who called it
*vacuum?
Its erroneous citation by the dark soul in jealous and
animosity!
Its magnificent book be full of wonders of universe.
Once I enter in to it I simply forget this world
It's my pal which consoles me when I was caught in scarce,
lonely hopelessness and looking towards it with a hope!
It's a lovely dove which lifts my soul on its comfortable wings
when my soul is full of worldly and wordily worries.
This space is an oasis which quenches my painful thirst.
When I lie in open yard, there lies a memorable talk in
between us.
So many words! So many songs!
It is stock of melodies giving me lovely and peaceful life.

* *In Indian context looking in to sky is called looking the vacuum in hopelessness.*

*It's a colorful, wonderful dramatic platform of
my life which can be solely seen by my soul.
It is swing for my tired soul.
My Life without sky is incomplete, that is why o sky! I like you*

30. Sea deceived

For those kids, Sea is play kit &play mate.
 *They fight with it in the game of**kabaddi.*
They swing on the tides until they get tired.
It chases and wipes out the sand sculptures built by them.
They join their tone in tune with songs of sea tides.
In this play field, they roam as tiny aquatic creatures.
After the breakfast with sea fish dish, they enjoy all the day
with the sea.
After blanketing it with the darkness, they sleep as agile sea.
Even during the sleep, they dream of games in the sea.
At the time of dawn itself they wish "good morning" with it
and come out of morning drowse.
If they are late by moment the sea comes to their
front yards and calls them for play.
During the full moon day's moon light,
they dance for the latest songs without knowing that
"late" becomes the prefix to their name.
For all these knottiest, sea is grand mom's crèche;
Endless Sea is their slate on which they trace alphabet.
Whenever sea is sick with depression,
they used to console it with their tender hands

* Kabadi is team game of India usually played by masses

They used to offer their snacks to it and coax.
Sea being synonym for their lives has suddenly rung the death knell.
Overnight it turned in to deadly night.
The sea which was jovial up to evening
became dictator and attacked them in the morning.
It made ropes with its water to hang and thrown on to their heads.
Became fanatic and blasted the landmines of tornado.
It made their front yards as grave yards and turned the melancholies.
Their loveliest darling sea targeted and took them.
Their play kit sea back stabbed its play mates.
It hunted the agile kids.
The innocent kids could not escape its coup.
Their tears joined the storming sea.
*The sea rushed with name of *Tsunami*
and easily cheated the cheerful kids.
Their "celebrity" sea deceived and celebrated.
The sky wept silently on this symbol of disaster.
The sea which took the cheers of kids
*slept just as old aged **witch***

* Tsunami is natural disaster occurred in Bay of Bengal and
 Indian Ocean in 2004.

31. Stream of song

*F*requently, I flow into myself.
 The world flows into me.
I flow into world
Flowing is my trait.
Stagnation is critical for me.
I am a perpetual flow towards infinite.
From group to loneliness, from loneliness to group I flow.
I flow from comfort to sorrow
I call sorrow into me.
I secrete tears of joy and sorrow.
I see the world in drop of tears.
My flow does not have limits and it has neither the beginning
nor ending.
I am the past giving the past to present.
I am an endless stream of time contained in a moment.
I am the gigantic light beam put in a small oil lamp.
My sigh consoles centuries of sorrow.
Just in a second, I enunciate ecstasy of human civilization.
I am infinite energy of sound kept in the pocket of silence.
I am silent meaningful light in a song beat.
I am the flag of dreams from the ground to heaven.
I am firebrand falling from the heaven to ground.
I become heartbeat of world in my stream of song.

32. Worry

No rains. If this continues paddy may not yield.
He may not get food grains. That is why poor farmer
deeply worries.
The favorite batsman at 50 not out.
If it rains, the game may be disrupted and he may not
complete a century.
That is why cricket fan deeply worries

33. Mr. Indecisive

His lips make reject..reject sounds as upch…… upch
The papers of his thoughts contain deletions, additions,
deletions
His dreams fly anywhere
At any time, he looks in to sky in pessimism.
And kills his time idly in a broken leg chair.
He cannot go up or go down
His name is Mr. Indecisive

34. Dawn and dusk

*O*ne dusk ended as hung radical
One dawn begins as alert new generation
In between there lies a restless fearful moment in time

35. Fag ends

*E*venings associate with circles of darkness around the sun
Every evening recalls the past glory and gets tears to
become twilight
It is an empty boat fought with the tides and reached the port
It is song by the unseen singer which lost the theme as volume
is inaudible.
This is run by the deer of broken legs
in an imaginary fodder field recalling its childhood
These are the roars by aged lions in caves
when they recall their youthful age
When we touch any fag end, it hopelessly looks
in perspective to find its specs lost in the dream valleys of
young age

36. I become a poem

I struggle a lot to become a poem
I prefer to be a poem than to just live as human
I love to live as poem
When I come out as a poem, the console I get can't be depicted
The elation is beyond words
Poem is spirit of my soul
Poem is my breathe
Life itself is a poem
Poem hosts my comforts and discomforts, my sorrows and shortfalls and relieves me from my pains &pleasures
Poem is mirror showing my image in ecstasy and ache
On a rainy evening when the rainbow prettify the sky
I become a poem
By seeing the pity of outgoing light up, poem enters in to me
I become the rebel's poem when I see rebellion against the anarchy
I can't live without imbibing poem in to me
I am agitated if I live without poem
Thus I become poem to take relief from it.

37. Saga for snakes

*E*verywhere snake holes
 Do not know their size
We do not know their roots
All along the way, below our feet
We do not know the hidden Karkotakas
We do not have any idea about Takshakas
As coiled around each, deadly snakes
Horribly hissing unnumbered poisonous snake coils
Many charmers blowing the nagaswaras and make the snakes
to dance
Many disciples to fill the snake bellies with milk
In the secret valmikams, the snakes enjoy like kings
Whenever there is danger, snakes get signals in advance
Then all those snakes hide comfortably in their cellars
The witch experts keenly take care of those snakes

Rarely innocent water snakes are caught
The actual deadly snakes bite us and the nation
They progressively develop without any fear
The snakes hug the nation by coiling from top to bottom
Every moment the nation experiences the death
Now the people of the nation have to do saga for snakes

*To protect the nation from snake bites**

* Yaga is religious ritual done with devotion and full commitment

38. Tears

*H*owever we can't live by denying the tears
 When the facts of life are understood, they console us.
*We may forego smiles in our life but tears last up to our last
breathe.*
*Whenever an innocent smile wishes you, your response is in
tears.*
*We may add colors to smiles but if we add colors to tears,
you are nearing the death.*
*Even for dictator, the realization comes in tears
When your soul corners you for your weaknesses,
then also tears substantiate you.*
In fact, the identity of humanity lies in tears.

39. When the omnipresent music occupies my soul

I feel all my life is seen, when I listen to music.
The entire melodies incarnate into myself and stand in front to speak with me.
A melody enters my joy and I dance in euphoria.
Another melody sounds all my sorrow
One more melody questions all my weaknesses.
The other one comment on my tears.
Sometimes I go in haphazard in to rain and play wetted.
At other times I become a stream and gush eroding the edges.
All the flower gardens enter in to my heart and blossom!
Constellations in the sky come in to my imaginations and move.
Current enters in to my blood vessels and get sparks of thrill
The magic of music makes me a stone and sculpts a statue in me.

Music crypts me in my loneliness.
There itself it burns and makes a holy man from those ashes.
Sometimes music teaches how to be elsewhere in others.
Thus I become nightingale, spring, and greenery!

I may also become Rainbow, moonlight, snow wetted grass,
Twilight.
Sometimes I befall in evening melody of sea tide.
I imbibe all that philosophy of nature.
I become free from all materialistic worlds, when the
omnipresent music occupies my soul!

40. Jubilant life

*O*ne who knows winning takes the failure as lesson
 One who knows weeping,
finds the roots of "weep" and learns smiling
Once the secret of smile is known,
the joy in journey materializes
Once the sequence of Climbing up at the dawn
and getting down at the dusk with
various paces in between is known, the perception changes
from self centered to self confidence.
For a human who,
Derives joy from watering a plant
Delights by giving flower to others
Energizes his wings to fly
Builds the way to bountiful life with self consciousness
Walks to make others to walk
just like the river bestowing waters in its flow
Scarifies the life like tree blessing us flowers,
fruits and finally its entire body.
Puts a foundation just like the earth
forming foundation when it is dug.
Knows life means "live and let others live"
Finally wins the "tears" by
defeating greed, violence, anger.

Washes himself to attain purity
Self enlightens,
goes with new and unique vision
*What else he finds except a **jubilant life***
What is Celebration?
Enjoying and making others to enjoy!
Moment, movement,
cheers cause the Celebration
When struck in cynicism,
I console you with my tender touch
And you come up as cheerful sky thus smiles.
go from me to you and you to many
uninterruptedly as fragrance of life
Look with probing vision!
What else we can see in the
innocent smile of an infant without any desires?
*Except **jubilant life!***
To make the life much more jubilant
Which we have to share
To make the life much more jubilant

41. O poet!

O poet! Where are the gestures of humanity
* which were nurtured by all your words which mystify*
as raindrops in those days and spread greenery
of kindness in the soil of souls?
Where is your tirade against the tides of cruelty and
untiring throws of paws on vampire
as parade in support of us?
Where are your dare devil deeds nullifying
evils and sounds of "left right "in resonance
to move us ahead?
Where are the human values cultivated by you
in which molesters and kind looking cruel were
ended and we were blessed with the peaceful life?
Now you tell me o my pal!
Can you hear the cries in despair?
Cries from the fainting innocent girl child?
Alas! How many more buds in kindergartens fall in this way?
How many flowers? How many cries in despair?
How long is this cruel maneuver?
The teacher who is supposed to set
example for others ethics is doing like this

*The teacher who is just like father becoming *Keechaka*
Fence grazing the crop,
eye lid doing deadly deeds on eyes
Who else can safeguard us?
The poet alone can convert the
deadly darkness in to delighting lights
You alone can do wonders which
the laws, rules can't do
I am telling you with my harsh words,
You being proud with your boasts of
dictating and directing this society with
your poems and columns, can't you stab in to such hearts?
With your poetic magic, will you join pollen grains
of kindness in to such souls?
By blossoming the flowers of ethics,
you nurture kindness in their die hard heart
and do the saga for making them human.
If it is as part of punishing them,
it becomes divine protection for us
(In the context of molestation of school girl in Bangaluru)

* *Keechaka is rapist Indian mythology.*

42. Age magic

*S*tarted life as single cell
Grown up as embryo in Mother's womb
Took birth as babe
Goes to school and grows as teenager
Tunes to counterparts tone
Enters the school of higher learning
To start earning
Earns and burn in desires to get wrinkles
Youth grows as elder and aged
As aged, suffers with sickness
Overcomes sickness and finally sickness overrides
Result is end of life
The only suspense is time and type of end.
What is all this nothing but age magic and god's logic

43. Secret

*T*he die cut diamond knows the pains behind its shine
 The friction it has faced, the fission it has tolerated
To glow with this florescence,
to adorn the kings golden throne
The tree branch with tender leaves knows
The summer heat, force of merciless gales
Due to which leaves fell one by one to make
it alone in melancholy of pessimism.
Lush green grass knows the days of dry spell
in which clay cracks and
Waits with thirst for rain drop,
The pleasure of germinating
greenness in fully wet soil of it.
The mouth watering fruit knows
the wounds caused by flies on
the flower in which petals drop
Colors faded,
the doldrums of the hanging tender fruit
with bitterness in it.
The resounding country drum knows the torture to
the body when its skin is swapped out
and smoothed with the sharp tools
the labor pains when heat treated on fire to send sound beats

Shall I tell you the great secret?
Every winner is a wounded soldier;
Stunning knit has a
backdrop of baffled lace work
He who bears the cross wins the death and
glows by unveiling new dawn

44. *ATA called me to America.

*R*eally I could not believe it at that moment.
 Then waver started for passport
and airport and went as hunt.
The fancy of foreign trip realizes
only when visa is Okayed.
"US trip is not so easy pussy"
my soul told me at that moment

At Madras in the race of VISAS, Many pale faces
American councilate is gate for our fortune

Mobs in lines at the early hours,
only few may get a chance.

Spent time with papers on pavements
If lords do not bless, come for next chance

The female who got VISA is Miss Monalisa
The male who got VISA is Mr Monalisa

* ATA is acronym for American Telugu Association

In my childhood, when I saw the air motor
and heard the sound in the sky.
Jumped and shouted in euphoria,
Ran like a train.
Today in Lufthansa flight at lonely night
Air journey is thrilling but
feeling of missing nostalgia

First flight journey is like bride of first night,
*first sip of *Blenders pride.*
What to tell, how to tell all this thrilling

* *Blender's pride is a liquor brand*

Bed scotch is offered by the air girl
But I would like to be teetotaler
Before I open my voice
She left towards the beer sirs
by pushing the bar trolley with beer bar offers

In this continent, our people are so great,
our pundits have to applaud
Even greater than the whites, studded
the US crown with Telugu gems.
In the dollar fort, our men settled with green cards
For those who proved themselves
life is cakewalk, otherwise way is block

Black boy black boy of Blacks Street
with diamond Black glowing eyes.
Fought and won against the slavery of centuries
from dark sheds of ghettos in shackles.
Called as nigger by the lords in louder voice.
O! Black boy of this black soil, you will rule US on one day
Probably you will rule it for ever

American girl like a white rose
is in the lovely arms of coarse black
Scene is so cute how to depict it
Yes
White hen in mate with black cock
For earning a dollar here
You have to work like road roller
*Our *Palamoor labor comes in to mind*
when we see these Mexicans.
American food costs more
The world has to beg it in mobs as slaves.

* *Palamoor is drought hit place in Telangana state of India from*
 where labor migrate to many cities in search of employment

45. Companion

A sparrow grabbed a space on the corner of lintel in my home
Not only that, I do not know
"who is the architect for it to design such beautiful nest"
It built a cute nest with straws and sticks
It uses my mirror to make up its cuteness
It enters and exits freely through my window
as if it is its own thoroughfare.
My home became its dormitory
Now it has two birdies to eagerly wait for its arrival.
My courtesy made it to own my home and keep its family.
Their sounds disturb me as I love silence.
At the time of cleaning my home
I plan to remove the nest.
But my hands do not cooperate for
it for the reasons not known.
Just recently I am habituated to live with them.
But grown up birdies left the nest.

After that their mother sparrow stopped coming to the nest
What a sorrow took place? I could not digest.
The empty nest created vacuum in my soul
as if my companion has left

46. Salute the dirt manager

*M*anaging obnoxious in busy junctions is his business
 He owns a trait of working hard to keep them clean
We hate to manage the dirt which we excreted
But he resides in such places of such obnoxious
He continues to keep the hygiene providing us the facility of
divinity of cleanliness
He is none other than SULABH toilet keeper
Let us SALUTE, SALAM, ADAB and what not for him
with pious heart

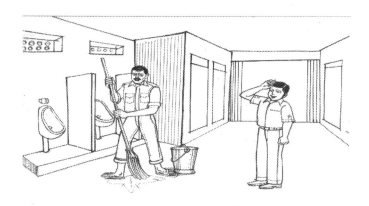

47. Except your apprehension, none can....

*F*eeling that
Some one has portrayed you as naked or else
distorted your personality,
donot go in to depression.
If some one tries to frighten you stating that
he uploads your half naked view in to net or set it as centre
spread
never care or bear.
The world is well known of your personality and nakedness!
World, Even if not known of your nakedness,
can't it imagine evenwhen you are in full dress
*Just like *Droupadi of that day, just like **Jaya of this day*
If revolted, rebelled and establish your selves in your own style
Those shameless fellows who created your naked views feel
shame of themselves.
If your parents and brothern cooperate to keep you in pride,

* *Droupadhy is Indian mythological women and she was attempted*
 for molestation in the court hall. She resists and revolts with a
 resolve to end them and succeeds

** *Ms. Jaya is Ex Chief Minister of Tamilnadu state in India whose*
 sari was pulled out to make her bare when she was leader of
 opposition. Later she fought and won the election to become Chief
 Minister of the state.

The world will certainly praise your win
All of us who are in one way or otherway impeached
must work out for such a great day
Let us get ready to aplaud and be aplauded.
Understand except your apprehension, none can....

48. I am multi edged

I am multi edged
I knit the songs for folks
I wit the stories for kids
I bid the poems for elders
I dance with buds. I sing with kids. I cling with the dads
My sword is multi edged knife winning the souls of many
By cutting fence of ego and putting bridge for easy going of
thoughts between all of us.

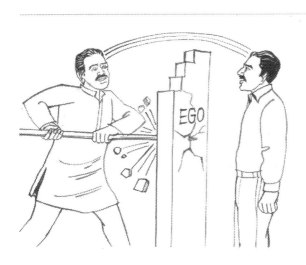

49. I personify in to a poem

I struggle a lot to be a poem.
I prefer to be a poem than to live as human.
I love to live as poem.
When I come out as a poem,
the console I get can't be depicted.
The elation is beyond words.
Poem is spirit of soul.
Poem is my breathe.
Life itself is poem.
Poem hosts,
My comforts and discomforts,
My sorrows and shortfalls
and relieves me from pains &pleasures.
Poem is mirror showing my image in ecstasy and ache.
On a rainy evening when the rainbow prettify the sky

I become a poem.
By seeing the pity of outgoing light up, I enter in to poem.
I become the rebel's poem when I see rebellion against the anarchy.
I can't live without imbibing poem in to me.
I am agitated if I live without poem.
Thus I personify into poem to take relief from it.

50. Mads make the world.

Socrates is first and greatest mad of this world
who questioned Greek clergy,
epics and faced death sentence.
Newton is mad because
he did not give the falling apple to his darling
Instead he hypothesized law of gravity.
Scientist who invented anatomy is stealing mad
because he used to steal buried dead bodies.
Copernicus faced the stone throws on him
and died as he was termed as mad by clergy.
He created history by chasing the mystery of
geocentric theory and stated sun is centre.
Archimedes is nude mad and floated
theory of floatation to test the gold purity.
*Jesus, Tolstoy, **Sri Sri all famous*
for their mad in their own sphere.
They made up their own world which
later became world for all of us.
Never mind to be mad to
elevate yourself to be a creator

* *Sri Sri is Famous Telugu poet who brought revolution in Telugu*
 poetry by breaking the shackles of metered poetry.

51. Morning star

*O*n every day morning he gets the globe on his bi cycle.
He runs in the street in alacrity.
He throws the world on to the main door and
goes to the next door in hurry.
He feels if he is late by moment,
it is late by a century.
None can bear his late.
If he is late,
Coffee does taste good on that day,
Stools stall.
He is the sun enlightening the winter darkness.
He is the cooler, getting the cool breezes in the summer
mornings.
He gets flash …flash on the flashing days of monsoon.
All the mornings wait for him and
his throws and none see in to his life.
He is the morning star,
Rising and disappearing instantaneously
while throwing the news paper.
His life consoles when he sits with
his head on knees after exhaust of all his energy

52. Nature is my teacher

*H*ow the birds give birth to birdies?
Why the birds of opposite gender
sit together and kiss each other?
How the cow gives birth to calf?
Why the farmer takes his
cow to big bull for mating?
How crops give grains similar
to their seed grains?
Why pollen is removed from
flowers in some crops?
Why flowers of two plants are kept in one cover?
Why 2 cobras dance together in
euphoria in a particular season?
All these doubts came in my little brain.
When I tried to find answers for these questions,
surprisingly I got a doubt about my birth itself.
Off course answers for all the above is similar and all these
Answers came from the surrounding nature.
Thus nature is my teacher which revealed the secret of
my birth

53. Random notes after a Spinal Surgery

I have endured years of pain
On account of a bad spine
I was told
My head would not hold
That I might bend like a bow
I might have to walk like a two legged cow

My first doctor had sagely advice
Get a bit of discipline and exercise
Ten minutes of exercise plain and simple
Would make you strong yet suitably supple

I said with due respect
You have missed an important aspect
I don't think the spine is of any consequence
For what I do or any part of my existence

There's more to physical pain
than mere vertebral degeneration.
I know, I come from a millennia old civilization

That lost its spine way long ago
a few hundred years to be precise.
I see it totter along without a spine,
no discipline, no exercise

 Just a sense of pride of having survived
 Occasionally it finds its head,
 Stands painfully on its crippled spine
 To proclaim that it is still not dead

I am a product of that wounded civilization
So dear Dr. don't you worry about the vertebral degeneration
Fix my head
And I can survive spineless, painless
Till I am hopelessly dead.

54. The man hidden

True man is always hidden like a tree
inside banyan seed wearing a
mask with a crown of dignity.
He plays a puppet show without any climax.
The secret scene is not seen in smiling words
but can be seen in his scoff folds of fore head
Many many concealed conclusions
in words uttered from his lips.
The true desires not seen in his opened
eyes but in his unseen vision.
The true man may appear in his emotions
but sharply disappears as snail hides in to its shell.
The true man waits for a chance as an archer
hides behind a bush and spider looks from its web
In a mob he may be known as "Gentle "and shine
with his fragrance of lit aroma sticks but
his insider is a question mark!
Tragedy results if we simply consider
his outer appearance.
In his loneliness he leaves his mask without
any shame and moves with his hidden desires.
The lively grotesques are like this and
how to trust his colorful pretensions!

Oh pal! You can tell a many from time database.
But the man is hidden and unseen
like a tree inside banyan seed and always
involves himself in some coup

55. Who said u r infirm?

*T*hough u r "armless",
 you avoid to be in others arms,
though they r firm to take you in to their arms.
Ur mere looks make their movements infirm
because u r firm and committed to your loving ones.
Ur looks send missiles weakening males' weapons.
Oh female! u r certainly firm in nature.
Only as coup to curb u, male called u an "infirm."
Come out of it and prove that
u r firm and counteract males' strength and coup.

56. *Vaddera **thalli

*H*er wage may be meager.
 She joins her better half
to make trenches to crunch their hunger.
She rarely sees doctor.
Balanced diet did not enter their menu.
She competes with her crow bar in leanness.
Yet she beats all the mothers in her motherhood to
feed the babe with her breast.

* Vaddera is a south Indian caste and they work hard to dig wells, trenches, rock cutting etc.

** Thalli is telugu word and it's meaning is mother

57. Eternal lovers

I am jealous to see your pair!
You go on doing your work round the clock
Never mind with the ongoing public or traffic
Without caring for the public,
you are dare enough to mate in every hour.
Declaring your love, you give sound of bells
as and when you meet and mate.
Hats off to u! o my dear clock hands! for your eternal love.

58. Soil is our Id

*U*ntil I saw
　　Green creepers,
Colorful flowers,
Tender leaves
I never felt that soil too dreams.
I never sense that, it also sparkle cheers
It hides calamities occurred long back
and hibernates.
All its memories are full of human fragrance.
Whenever we dig,
we get wonderful experiences which
come out in lumps and dumps.
High handed prides,
cute curves which made men to follow
hidden coups and
many such had deep sleep in
the soil layers.
While the present dancing on the surface,
The past freezes inside.
Somewhere at abysm,
future gets the wings.
Soil's is silent articulation
Soil takes an endless breathes.

This is the soil in companion
with water feeds us!
Soil's is great sacrifice
Soil's is great saga for love.
Though men has many sky scrappers,
flies in his dreams,
As and when dug, he finds fragrance of soil.
Man is an articulating soil.
Thus man identity lies in soil.

59. Silent pollution

Not sound,
 Now silence is great pollution.
All houses gloom in colors.
Walls downing from sky,
make it sound proof.
No talks in between any.
If at all there,
Only cheating chats to pacify the desire.
World of their own for everyone.
After nets, sites banned the talks,
After TVs, laptops stitched the lips
After systems ordered curfew,
What is left except silence of graveyard!
Where do we find chirps in this global village?
Now man dwelling in sound poverty.
He became beggar for few words.
Childhood without any games and tames
stormed in race of competition.
Elders lacking concern are dwindling in old age homes
Mob silence,
Chasing silence,
It's biting the life like cancer.

Man became a helpless bat
hanging from a lifeless tree branch.
Biting silence, breaking silence
suffocation with silent pollution.
The post modern man with charmless eye balls
enters into talk less life of well decorated mausoleum.

60. Seeds of Sweat

*L*ife is *top of a moment.
 Life is inevitable,
Living too inevitable
During the life,
Time pass with the
tied bonds is also inevitable.
Well thought idea is better than momentary ire

We
Come as drizzle of thoughts,
Downpour of thunders,
Sparkling wires.
Never death is climax
Resolve to live is superior to end with death
For the hands transplanted paddy,
Is it so difficult to be ignited?
Seeds of sweat tilling the soil have to germinate
to shine as green crops.
To give us cool shade and stand as companions

61. Who's God is Deaf ?

*I*n the name of festival,
 Horrible drum beats,
Horrifying foul cries,
Terrible shouts in mikes
Terrorizing the ambience
Why all this,
Do you accept your god is deaf?
To ask peace for you,
Is it right to curb others peace?
It is the time for your prayer
Not for others!
If it is your prayer, reach the god
With your surrender to almighty
In the name of your prayer,
If you curb others silence,
They may have to pray the lord
To silent you or
Your god may have to accept that he is deaf.
Don't make him deaf with your sounds, beats, rites

62. Let *Godarri be Godaari not *Ganga

*L*ong Back River Ganges (Ganga) is pious
As it was pious, everybody dipped in it to wipe out their sins.
Some big shots dipped Ganges with their pollutants and emissions.With all their sins Ganges is no more pious.
River Goodari is popular as Dakshin Ganga (Southern Ganges)
Now feared of its fate!
As its northern elder sister has lost its status of pious,
Many may take dip in it & dip her at last.
Oh my dear believers
Don't dip Dakshin Ganga with your sins
Shun your sins elsewhere
And keep this river giant of south
Pious and perennial.
Chemical *Holis, *Ganesh immersions cause to lose its Holiness!
Pushkarams must make the river holy
With your holy contributions and lovely deeds.
O my dear river lovers,

Let Godarri be Godaari not Ganga

* *Godaari, Ganga are Indian rivers of south, north respectively.*

* *Holy is Indian festival colors.*

* *Ganesh immersion involves colors*

63. When it dawns

When it dawns
Shades awake
Colors arise
Shimmers in all directions
Flickers in wings

Men wave up
The flood of streets

64. *Padyam-the- un withering flower

Padyam - The flower that does not wither
 The flower which retains its fragrance forever

Countless centuries pass
Many padyams still afresh
Emitting their fragrance

 The padyam does not reach those
 Who lack exquisite aptitude

* *Padyam is metered poem (Chando bhadhamina kavitvam)*
 of Telugu language

65. Cob's plot silk worm's slot

Cob plots with its gummy weaves
 to capture other insects and eats
Silk worm eats the leaves which
 provide the seat for it

Cob eats the insects and
 remains as insect

Silk Worm eats leaves
 changes into ball
 as the ball is prick
 fructifies into thread roll
 extends into glittering weave

In festivity touches the body and
 Lives with the glimpses
 to become eternal

Cob's plot is selfish
Silk worm's plan is sculpt
 Selfishness has no progress in evolution
 Life with sacrifice makes the sculpt to go ahead

Life

> An art of experience
> Sculpt of sacrifice

Indian poets who contributed poems for this work

Dr. Kavoori Papaiah Sastri

Mrs. Talluri Subba Lakshmi

Mr. KBDL Stone

Dr Yendluri

Prof. Raama Chandra Mouli

Mr. Potlapally Sreenivasa

Mrs. Devulapally Vani

Mr. P.Subbarayudu

Dr Talluri Ravi

Mr Raparthy Shankar

Mr. Gurijaala Raama Sheshaiah

Printed in the United States
By Bookmasters